THE CIRCADIAN TAROT

THE CIRCADIAN
TAROT

A Daily Companion for Divination and Illumination

BY JEN ALTMAN ARTWORK BY MICHELLE BLADE

CHRONICLE BOOKS
SAN FRANCISCO

INTRODUCTION

WELCOME TO THE CIRCADIAN TAROT

Creating a relationship with Tarot can be a richly reward-
ing endeavor. You do not have to subscribe to a particular
faith or religion to learn from its enlightened messages.
There are no set schedules of when you must practice,
but the more you interact with Tarot, the more you will
feel an impenetrable bond forging. Reading Tarot for
yourself, and eventually perhaps others, will open your
heart to fresh ways of viewing the world around you
and your unique role within our universe. Tarot seeks to
open your mind's eye to the possibilities that now lie dor-
mant at your fingertips and not only pushes you gently
to question your outlook and life role, but also reminds
you that the best version of yourself is waiting to break
through the darkness.

While the art of divination is as ancient as mankind's
desire to unfold the silent secrets of the future, Tarot

cards date back only to the Italian Renaissance. Created originally as a game, they weren't used as a tool of divination until the French occultist Jean-Baptiste Alliette, better known as Etteilla, published his work on the subject in 1791. Since that time, countless variations of Tarot have been produced, but none is more recognizable than the Rider-Waite deck, which was illustrated by Pamela Colman Smith and based on instructions and guidance from the mystic and author Edward Waite. For many of us, that deck was our first encounter with this magical practice.

Each reader's relationship to Tarot is unique. Hundreds of collections have been created so that readers can connect with Tarot based on their own desires and preferences. As such, the aesthetic and design must speak to you not only visually, but spiritually as well. We've reimagined Tarot as a book, both artful and divine. Unlike with a traditional deck, in this book the interpretations of each

card lie at your fingertips, making the book itself unique within the world of Tarot. We hope that Michelle Blade's gorgeous and sublimely surreal imagery found within the pages of this unusual "deck" speaks to you.

HOW TO USE THIS BOOK

The book you hold in your hands is a tribute to the art of Tarot. Tarot is an open-ended practice, and as such there is no one right way to use this book. However you peruse these pages, the messages of Tarot will help you to see your life in a new light.

While there are countless approaches to reading Tarot cards, this book uses the single-draw method. With a traditional deck, you would shuffle the cards several times, cut them into three piles, and stack them together again to draw a single card from the top. This card can be used to either answer a question you held in your mind while shuffling (a question reading) or as an oracle to guide

your day (an open reading). Much like a daily horoscope, a single-card reading can give you insight into what you can expect from your day, or thoughts and feelings to be mindful of.

To read this book for your divination of the day, find a time when you have a quiet moment to yourself. If time and space allow, light a candle. Open this book, close your eyes, and attempt to clear your mind. Be open to receiving the message the cards wish to bestow. Flip through the pages as much as you need to, your eyes still closed, until you feel ready to stop. The page in front of you is your oracle for the day. Take a moment to study the beautiful imagery. How does it make you feel? What is your initial reaction to the image? Read the written description of the card. Open your mind's eye and reflect on the message and how it could apply to a variety of aspects of your life at this moment. It can also be helpful to keep a journal of your daily readings.

Remember that Tarot is a guide; it attempts to illuminate things that we often keep in the shadows . . . what is this light clarifying for you today? If the answer is not immediately clear, start writing . . . the answer will come.

For the best reading, it's important to connect with your cards. Some of the same rituals that practitioners use to "cleanse" or "clear" their decks can be applied to this book. Always cleanse the book before its first use if you've allowed someone else to handle your book, if you have not used the book in some time, or if you feel confused and misguided by the readings. A quick clearing can be as simple as shuffling or flipping through the pages intently—back and forth—until it becomes meditative. This can be a wonderful way to clear energy before each reading. Before your first reading, or after a long break, try lighting a smudge stick (a dry sage bundle) and passing the book through the smoke several times. Keep your mind focused and open. While it may be tempting to rest

your book ribbon near cards that you feel connected to from previous readings, you will derive more accuracy by allowing your instincts to guide you as you meditatively shuffle the pages.

READING TAROT

Tarot cards are divided into the Major Arcana (or Trump Cards) and the Minor Arcana. If you study the chronological sequence of the Major Arcana, you will see that it speaks to a universal life journey, one that starts full of hope and innocence, weathers storms and heartache, and ultimately finds redemption and joy. They are also referred to as Trump Cards because their messages are often considered more central to our journey than those delivered by the Minor Arcana. The cards that comprise the Minor Arcana speak to the details of that journey and focus on our day-to-day affairs and emotions. The Minor Arcana itself is divided into four suits: Wands, Cups, Swords, and Pentacles. The Wands are linked to

the element of fire and speak to our desires to grow and to reproduce (both creatively and sexually); the Cups are linked to water and communicate messages about our spirituality—they are connected to our emotional being; the Swords are linked to the element of air—they speak to our ethical and analytical reactions, as well as the darker aspects of our life journey; and finally, the Pentacles are linked to earth and deal with our home and work lives and finances. Additionally, each suit in the Minor Arcana includes four Court cards: King, Queen, Knight, and Page. While these cards can represent an event in your life, most often they refer to a person or an aspect of your own personality.

The more time you spend with your Tarot book, the more acquainted you'll become with each card's divination. You may find that you chance upon your daily oracle and need only absorb the beauty of the card itself . . . your heart and head know the message.

THE FOOL is a symbol of quintessential beginnings and complete innocence. Like a newborn, and because of the naivety implied, you are primed for enlightenment. Now is the time to jump into the deep end and start swimming. Risk calculation rarely comes into play when the Fool starts out, however. This is a reading that encourages living in the moment, but be mindful of missteps. Take a moment today to take a deep breath and step back from the precipice; allow yourself to indulge in the excitement of a new journey, but ensure that you've considered all opportunities before moving forward.

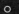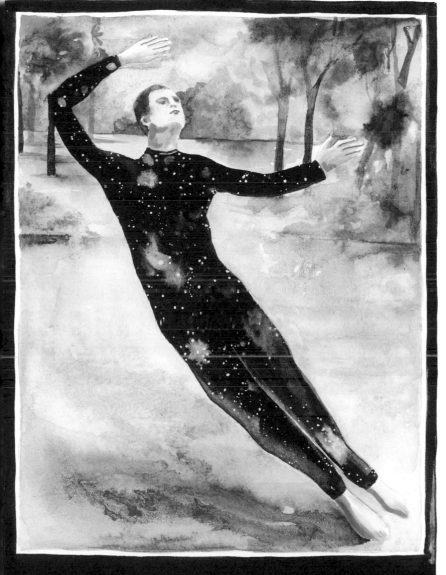

THE FOOL

THE MAGICIAN is a symbol of limitless power and a reading that calls upon your intense focus and utilizing your unique skills. It speaks to taking action and honoring your self-empowerment while maintaining diplomacy. You are facing a challenge in your life, and the Magician is reminding you that you have the strength and will to succeed. Spend time today reflecting on your desires. You know very well what your heart needs, and this is a reminder that your time has come. The world is open at your feet, and you have the great power within to manifest these dreams; it's time to act. "Action" is your power word today.

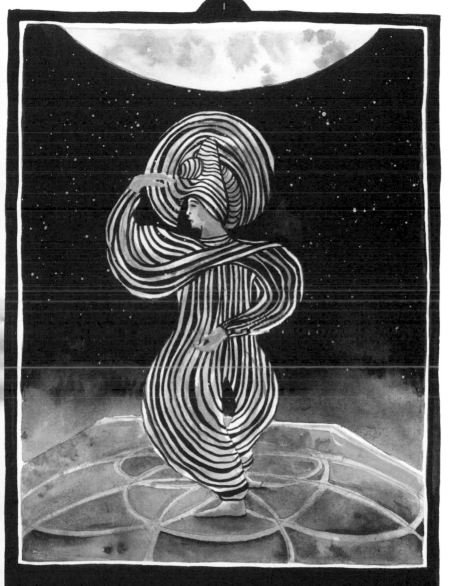

THE MAGICIAN

The full moon follows **THE HIGH PRIESTESS** in all her endeavors. A symbol of mystery and deep wisdom, both the moon and its Priestess are the female balance to the swift action asked of the overtly masculine energy of the Magician. She's also associated with the darkest place within you, which you veil from others. Her presence is a reminder to go deep into your consciousness to awaken what has always—but unknowingly—slumbered within. She asks you not to take action to solve a problem at hand, but to take a moment today to honor the silence and look within yourself for answers.

THE HIGH PRIESTESS

THE EMPRESS is a true mother, and her greatest power is conception. She's closely associated with nature and encourages us to love unconditionally: both ourselves and the world that surrounds us. She also has a seductive side, and her sensuality is tied closely to creation. This creation can manifest itself physically (as in a pregnancy) or mentally (inspiring creative energy in your work). She asks us to embrace our own sensuality and connect with flora and fauna alike—thereby inspiring our sparks of creativity. Spend some time outside today to honor the Great Mother; feel the cool grass between your bare toes, dig your fingers into the earth, and be inspired to find new ways to honor the world around you.

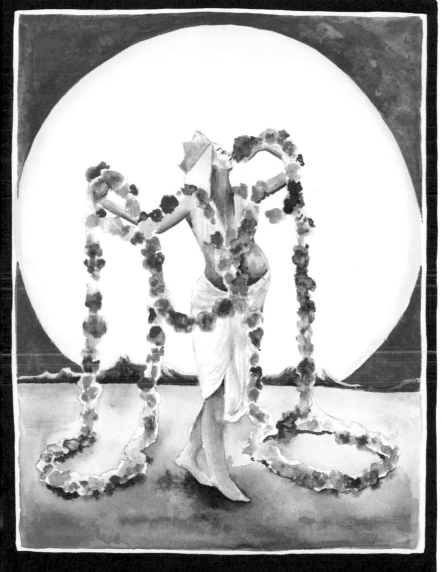

THE EMPRESS

Unlike the Empress, who uses her heart to shape the world, this father figure uses his mind. A paternal soul, **THE EMPEROR** is fiercely protective and symbolizes stability and logic. While he can sometimes speak of a particular figure in your life, he is more commonly associated with an issue you currently face that requires thoughtful study. Whatever the issue, this reading is a reminder to check your emotions and apply thoughtful intellect to the situation at hand. Look to the patriarchs in your life—what advice might they give you about what you are asking of the universe? Listen and honor the quiet strength of their voices.

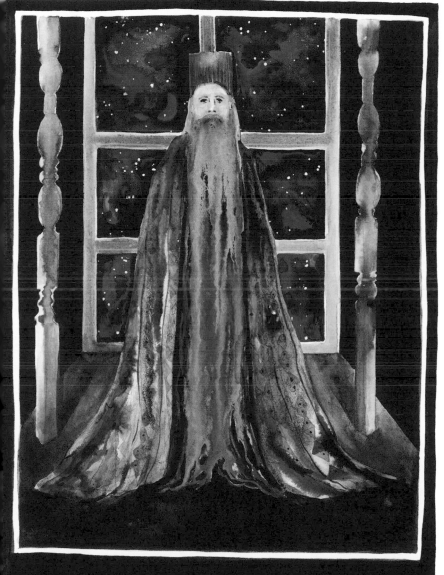

IV

THE EMPEROR

THE HIEROPHANT is a symbol of communication, especially that within the realm of faith and spirituality. He holds secret knowledge in his heart but is open to sharing these mysteries with the right student. You've been traveling a spiritual path, perhaps unconventional or traditional, for some time, attempting to connect with a power greater than your own. There is only so far self-study can lead you. The Hierophant inspires those who are on the precipice of spiritual growth to seek out a mentor or teacher to gain new enlightenment. It's time to emerge from the shadows of your own spiritual realm and join others on your journey.

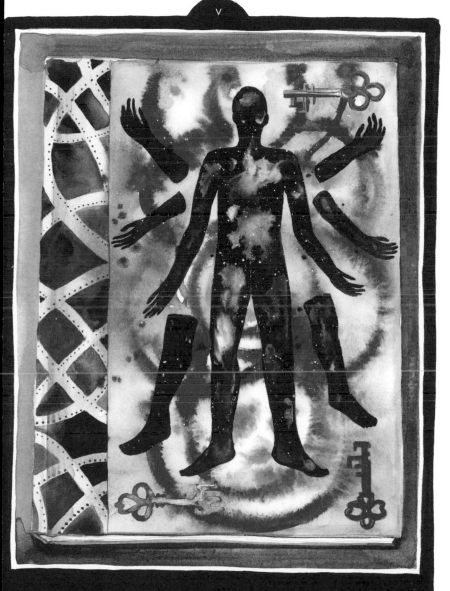

THE HIEROPHANT

THE LOVERS symbolize union and, often, desire. Love is a great gift, and when attraction and desire are made manifest, our hearts and physical needs answer so quickly, almost feverishly, that we can feel as if we are drowning in the flames of lust. Open your heart and welcome love, but be cautious; the intensity of these emotions can often lead you astray. The Lovers can symbolize a blessed physical union between two people but can also tell of trials overcome and choices to be made—often with the heart as opposed to the head. If you find yourself succumbing to the desires of a new love affair, take a moment today for yourself. Remember that you alone are in control of your heart and its love song or lament.

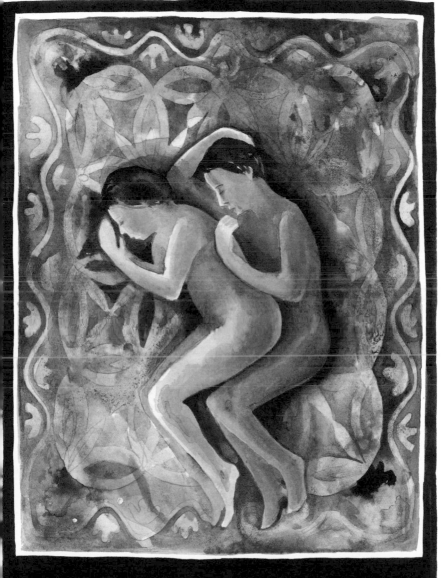

THE LOVERS

THE CHARIOT overflows with energy and promises of triumph. It represents action in all realms of your existence. You know in what direction you must travel, and the Chariot foretells your strength, confidence, and ultimately, your sweet success. It reminds you that certain setbacks should be viewed as new and engaging opportunities. You are in control of your destiny, and your inner warrior is ready to conquer whatever may lie in your proverbial path. Spend time today visualizing your path to achieve your goal; create a list of any obstacles that may be in sight. Be mindful of the pros and cons in the situation as the Chariot often asks you to dive head-first . . . be judicious and flexible, and you will realize your desires.

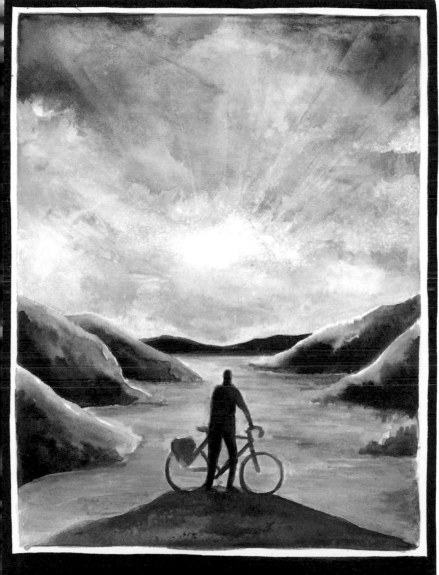

THE CHARIOT

The great lion is a symbol of power and courage. This card speaks not so much to physical strength as it does to your determination and self-control. The appearance of **STRENGTH** indicates a great power and energy at your fingertips, but it also beseeches perseverance. When the lion hunts, she lies in wait, patiently contemplating her prey. We all have a quiet and potent force within us. How do you channel that energy to attain your desires? Try to rise above the emotions that attempt to influence your decisions, and be steadfast in your resolve. This card can also foretell new beginnings and the focus and determination required to see your task through to the end. The lion asks you to be patient, steadfast . . . and strong.

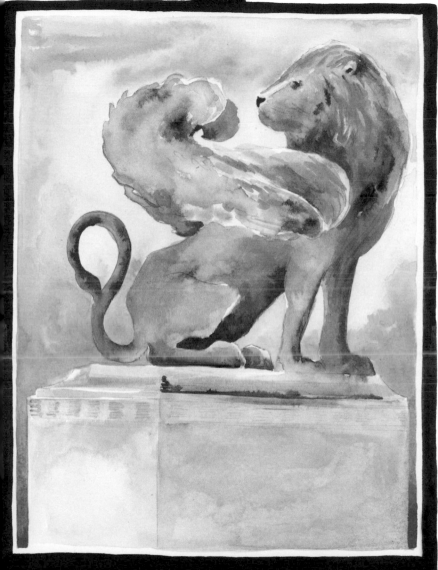

STRENGTH

THE HERMIT symbolizes a journey inward. He speaks with the most clarity after you've endured an arduous emotional or physical journey; the Hermit reminds you to calm and replenish your soul. He asks you to take a moment away from the day-to-day matters of your physical existence and create a sense of stillness. This is the time to experience solitude, to meditate, and to let go. Retreating within yourself allows you to reevaluate, gain insight and knowledge, and ultimately move forward once again. The Hermit demands self-reflection and ensures that you will survive any trial because of your strength of mind and will. Today, light a candle, close your mind off to distractions of the outside world, and journey inward. Slow your breathing and focus on the Hermit . . . where does he lead you?

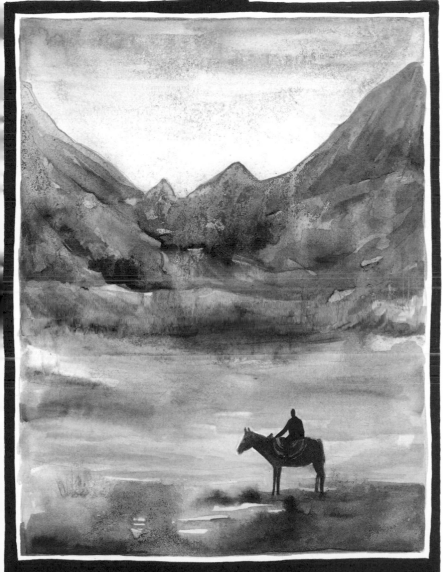

IX

THE HERMIT

Life is akin to the ocean; it ebbs, flows, and churns with joy and heartache. The proverbial wheel of life continues to turn, as does your fortune. One of the most welcome readings in Tarot, the **WHEEL OF FORTUNE** foretells great happiness and fulfillment. You've been through so much, and now you are destined for positive change and success. This reading encourages you to embrace fate and believe in the power of the universe and, ultimately, your destiny. Today, focus on keeping your heart open and visualize your desires; all of your wishes are about to come true.

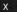

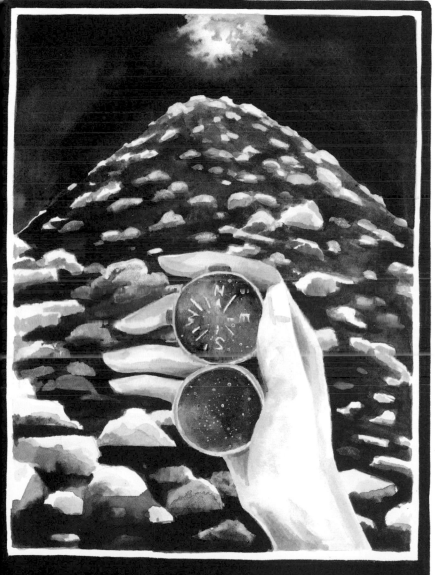

WHEEL OF FORTUNE

The **JUSTICE** card can directly represent legal matters at hand, but more generally it symbolizes karma. Decisions made long ago can come back to hinder or help you. We are only human, and very often we act out of impulse and desire rather than love and a sense of what's right. If we listen to our hearts, we find that we can learn and grow from those missteps. You may have to face the consequences of your prior actions, or this reading can be a forewarning to be careful of your choices regarding a matter at hand. Use this message today as a reminder to always be judicious, fair, and mindful in your interactions with others.

XI

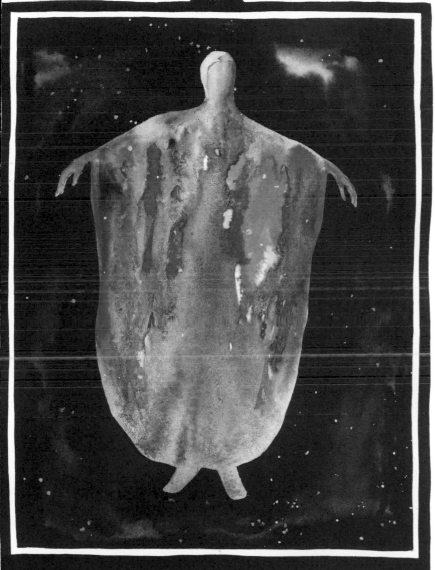

JUSTICE

At first, the symbol of a man inverted—**THE HANGED MAN**—can make you feel as if doom is at your doorstep. Take heart; it is a reading that transformation is at hand, but not without sacrifice. You may have worked diligently with steadfast determination on something—maybe a relationship, maybe a work project. Now you find your progress may be at a stalemate. The Hanged Man is asking you to shift your perspective in some way in order to move forward. Like serpents, we must shed our skin to continue to grow. Today, reflect on how far you've come. What must you change or give up in order to shed your skin?

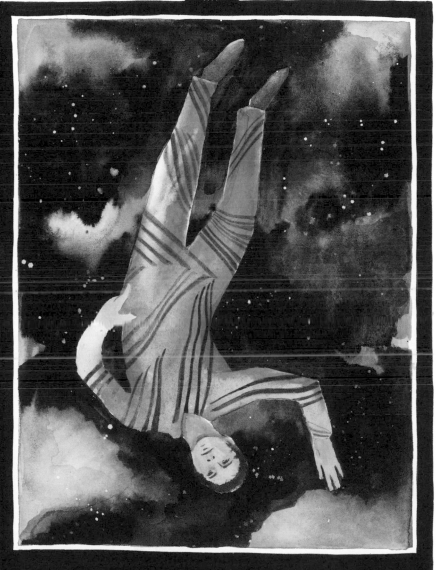

THE HANGED MAN

Just as skulls have historically symbolized renewal and regeneration (both of spirit and the physical), so does the **DEATH** card. It can be frightening to see this card, but it foretells a necessary ending and the need for closure so that you may be born anew. Change is not easy, and you may have been fighting it for some time. It's time to embrace the inevitable and make peace with the part of you or your life that is passing on. Only with this acceptance can you move forward. It can be very difficult at the time, but this card will bring purification and, ultimately, new life.

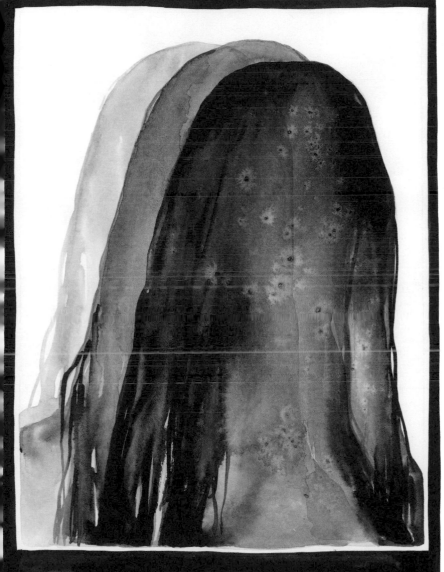

DEATH

TEMPERANCE invites moderation and asks you to balance certain aspects of your life. You may have found much success in one facet of your life while not taking the time and energy to nurture another. You may be healing from recent trials, and in order to do so successfully, you must respect the balance of Temperance. It asks you to adapt with maturity and maintain diplomacy in your actions. Maintain the middle road and avoid extremes right now, and through this journey you will connect with a deeper sense of self.

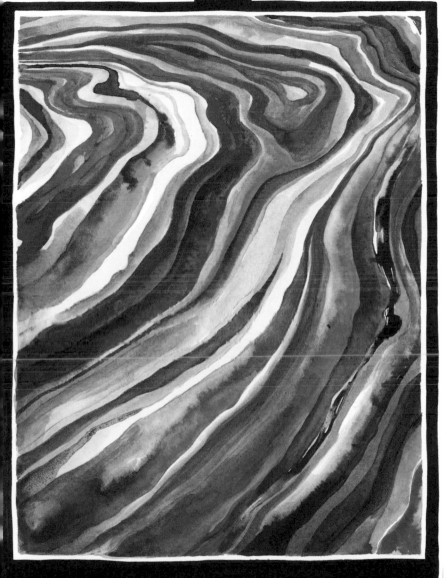

TEMPERANCE

A warning. **THE DEVIL** cautions that you have neglected the spiritual fulfillment of your body and soul. It is not an external force that's attempting to corrupt you, but your own fears, negativity, and dark shadows. Only by accepting your inner darkness will you find the resolve to see the light once more. Some great force has a hold on you, and it's time to slip its grasp. Step into the sunshine today and make an effort to reconnect with those in your life who are healthy, balanced influences. Through their inspiring energy, and your fortitude, you will rise from the darkness.

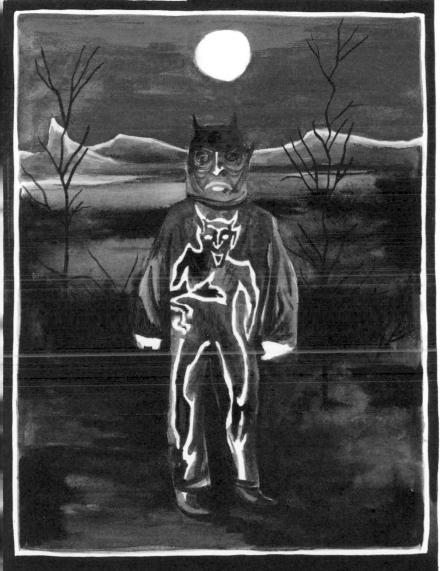

XV

THE DEVIL

THE TOWER speaks of sudden loss and upheaval. It signifies abrupt and dramatic changes to your well-established routines and life. The walls that you so carefully crafted around you are falling away—completely out of your control. This loss can be physical or emotional, and the experience can be shocking and unwelcome. And though it may be difficult to imagine things ever being better—or as they once were—this card also foretells a rise from the proverbial ashes of that destruction. Much like the Death card, the Tower is a reminder that though the days will be dark and full of anxiety now, in the end you will be free and renewed.

XVI

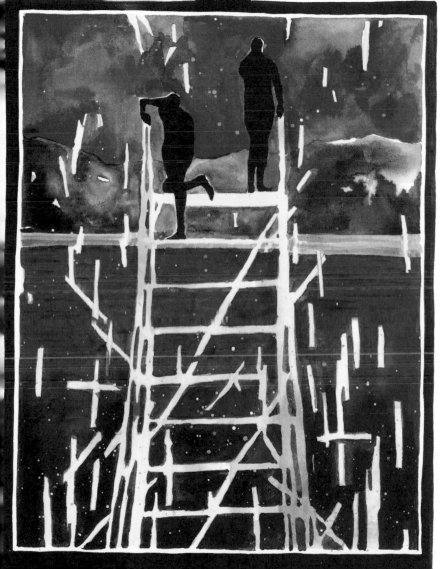

THE TOWER

THE STAR follows the intensity of the Tower and is a symbol of hope and brightness for the future. You've seen your trials through; you find yourself emotionally drained from the ordeal. But the Star is here to remind you that your future is shimmering with happiness. It is one of the most positive cards in the deck and speaks to contentment—the kind of blissful joy that we carry within ourselves and manifest in every aspect of our lives. While it may obscure answers to the question at hand, it encourages you to listen to your heart, and it will surely lead you right. Today, allow yourself to embrace the possibilities of your future . . . they are so bright.

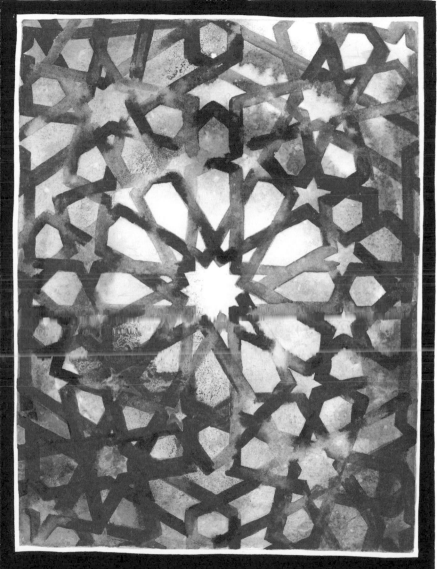

THE STAR

In folklore, the moon is associated with mystery and hidden truths—and so is **THE MOON** card. You may feel as if you've been stumbling through a dark wood, the moonlight peeking its way through the bare branches but failing to fully light your path. This card forewarns of lack of direction and possible hidden enemies (these can be other people or your own unspoken fears). It is a card of the unknown, and you may feel that you will never reach the end of your path. But allow your intuition to be your guiding light through the darkness. Trust the physical and emotional reactions your body experiences when dwelling on the issue at hand. Believe in yourself and your natural instincts, and the moon will illuminate your way.

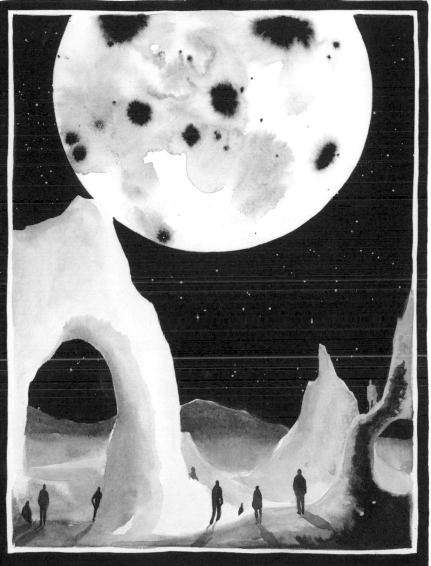

THE MOON

THE SUN is an extraordinarily powerful and uplifting reading, and a symbol of strong health and vitality. The Sun banishes the darkest shadows to rise high into the sky, illuminating your world. You possess its warmth and are radiating with positive energy. You may find people drawn to you and the light that you are subconsciously harnessing. The Sun also signifies completion and overwhelming success. Your confidence is high, and it should be, for everything you touch seems to turn golden. Today, focus on what you've accomplished and the rewards bestowed upon you. Remember to be grateful for such gifts and to share your joy and elation with those you love.

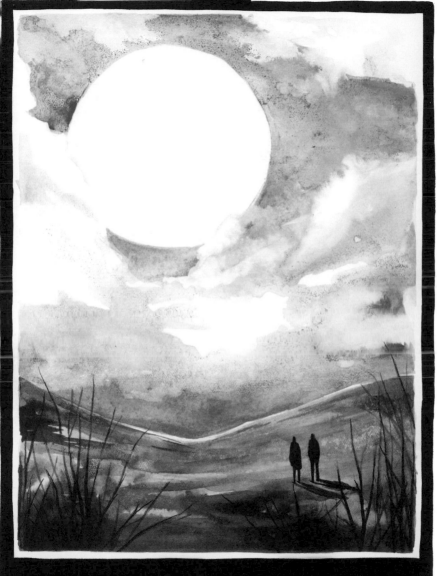

THE SUN

THE JUDGMENT is the last card of transformation in the Major Arcana. A card of transformation foretells great change in your life, and in this case, it indicates a care-free and clear path. You've been given a blank canvas and are invited to create a future of your own design. It is a reminder that change is anticipated, but its outcome is solely within your power. Today, reflect on your past to rectify any wrongs you've initiated, and through this cathartic course, you will find yourself physically and emotionally absolved. This reading asks you to embrace forgiveness and honesty, and to let go of the past, in exchange for spiritual awakening.

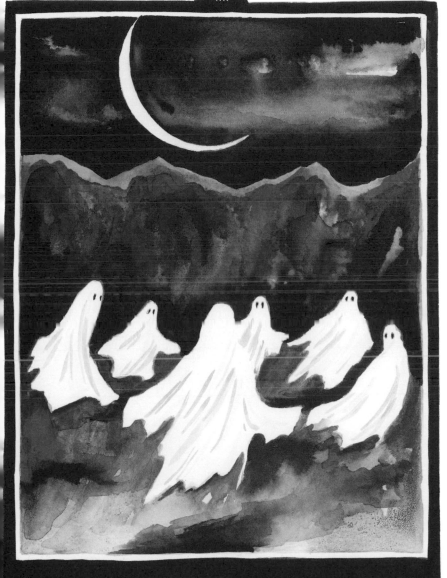

XX

THE JUDGMENT

This is a reading that speaks to your recent accomplishments and to attaining inner peace and contentment. You've recently completed a long journey, one that was full of challenges and perhaps heartache. But the sun has risen once again, and its energy and radiance fill every aspect of your life; **THE WORLD** is yours. We often are so consumed with what is coming next that we don't take the time and energy to acknowledge our success. The World reminds us that it's important to our spiritual and emotional well-being to honor these triumphs and radiate with the joy of victory. Today, be mindful of this balance—enjoy your success, be grateful for it, and savor every moment of your bliss.

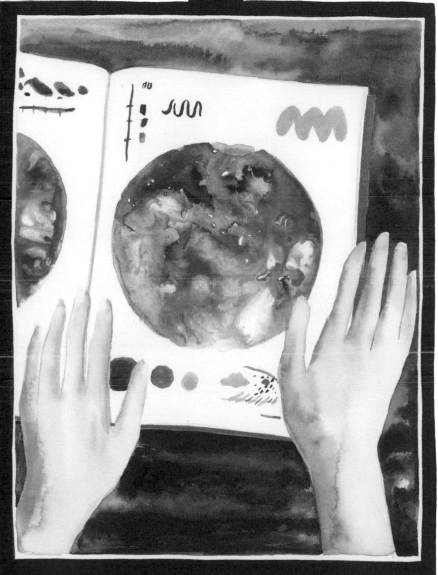

THE WORLD

The **ACE OF WANDS** invites you to harness the power of creative conception and labor. A spark of inspiration has ignited and with it powerful new ideas. Employ the command this card gives you quickly, as your creative desires will seemingly bend to your will. If you wait too long, the firepower will be extinguished. Do you have a new idea that's been simmering near the surface of your consciousness? Maybe you've been fearful of deploying your tenacity to get started . . . today is the day. Cast your apprehensions aside and dive in. Do be mindful that akin to all fire, this power can be unpredictable. Don't let fear of the unknown deter you, but keep your eyes open.

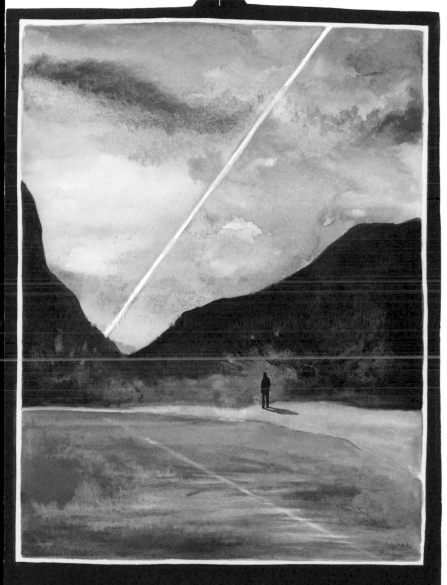

ACE OF WANDS

Look to the **TWO OF WANDS** as a call to apply newfound powers judiciously and with resolve. This is a reminder that life's choices ultimately are our own responsibility. Every step we take through our own timeline should be with intent and purpose. Today, channel your determination and willpower. There is a path that you are meant to be traveling, and often that path can lead to unexpected destinations. The Two of Wands reminds you that you have the ability to fulfill your desires—stay focused and open to possibility.

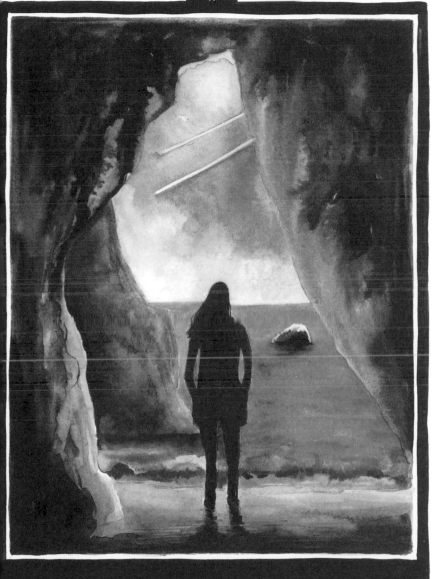

TWO OF WANDS

The most inspirational and enlightening voyages are usually journeyed alone. We tend to connect to a deeper sense of self when we experience the world outside of our average existence. It's time to look to a journey that will bring discovery and new enterprise; your endeavors will result in self-reliance and success. The **THREE OF WANDS** reminds you that you are ready for such an undertaking. Be brave and adventurous, and not only will you reap the life-altering benefits of fulfilling your wanderlust, but you may also experience visions of your creative future.

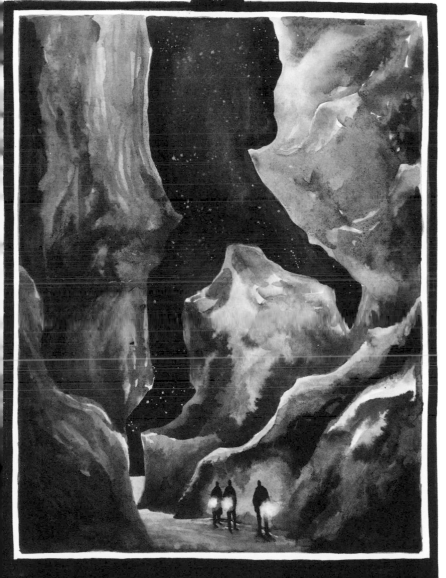

THREE OF WANDS

One of the happiest readings in Tarot, the **FOUR OF WANDS** encourages you to embrace the joy in life and to reflect on the tasks you've worked so hard to complete. A reminder that focus and perseverance pay, it's a card of celebration—the sublime contentment of a life well lived. It can also indicate that a significant event is on the horizon: a marriage or a birth perhaps. In short, it's time to celebrate. Invite friends and family over for dinner soon; make plans to reconnect with loved ones. Channel this euphoric state into your next project, for as we are all aware, the wheel of life does not stop turning.

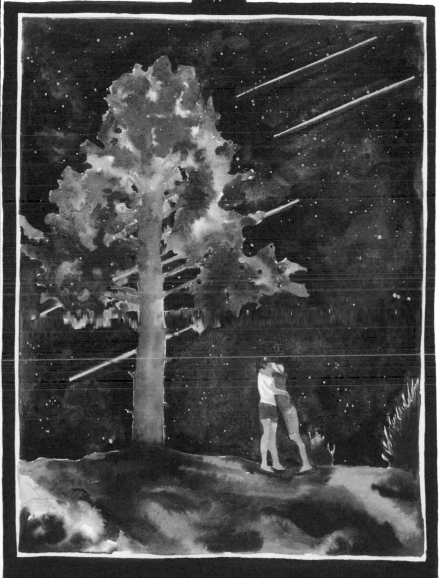

FOUR OF WANDS

You may be feeling at odds with someone, and often, that someone is you. The greatest battles we will face in our lives are between our hearts and our heads. The clarity with which your head can often visualize a problem at hand can easily be clouded by the emotional weight of your heart. If you are at an impasse with others, the **FIVE OF WANDS** warns that you may need to resolve inner conflicts before you can find closure. But it also encourages you to stay focused and clear-sighted about goals, and to overcome hurdles to reach them. Take a deep breath and do not allow your emotions to cloud conflict, but instead, face it with your head sharp and eyes open.

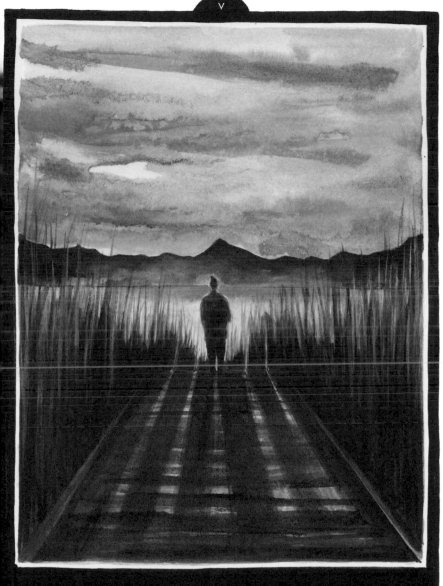

V

FIVE OF WANDS

You have recently overcome hardship and struggled to rise from the ashes; a physical or material victory has been realized. It is now time to enjoy your spoils. Take a moment today to acknowledge your success. Socialize and celebrate you; there is no shame in being proud of all you've managed to overcome. There is another underlying message the **SIX OF WANDS** shares that is directly tied to your successes: a warning not to allow arrogance to overcome you, a cautioning to stay grounded and grateful. Be mindful of this as you enjoy yourself.

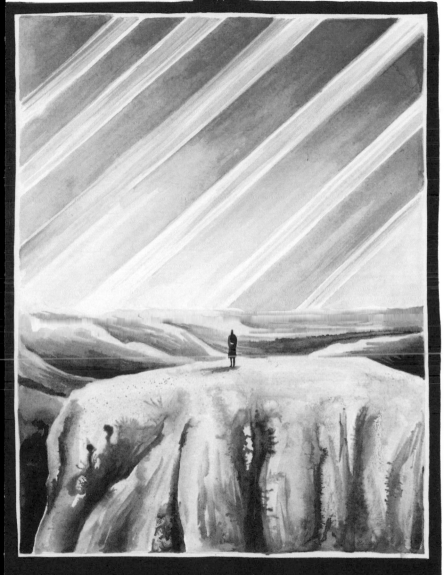

SIX OF WANDS

Often, we gain the most strength by confronting fears that have abated our progress for some time. It can be emotionally and physically daunting to not only acknowledge these fears, but to combat them. The **SEVEN OF WANDS** is an encouragement to have resolve and face those anxieties head on. It also reminds us that standing your moral ground is never easy, and that the road will be difficult but in the end richly rewarding. The Seven of Wands calls for your deepest inner courage. What are you ready to fight for?

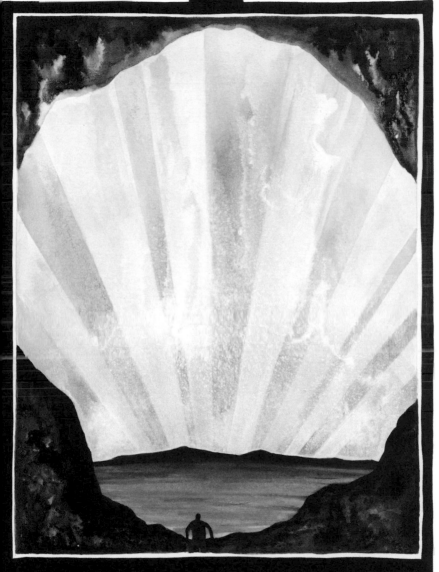

SEVEN OF WANDS

A path that once seemed blocked is suddenly clear, and you will experience a burst of energy going forward. This is the power of the **EIGHT OF WANDS**. It's a reading bursting with action and vitality. Its primary message is that it symbolizes swift action against seemingly unmovable forces. As with all Fire cards, however, be mindful of rash decisions on this road. The power pushing you forward is exceptionally strong, but that does not negate your responsibility to think and act clearly. Today your power word is "go"!

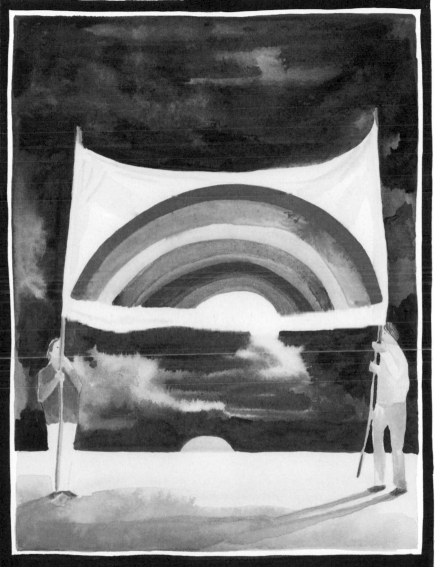

EIGHT OF WANDS

The **NINE OF WANDS** demands your fortitude. You are being asked to stand boldly against opposition; this card is the last great mountain to be climbed within the Wands suit. You've traveled the peaks and valleys with focus and determination, and you now reach the last great test on your journey. You will face something difficult and challenging soon, however, and the Nine of Wands is a reminder that your inner strength and perseverance are your allies, and success is at your fingertips. Be mindful today of honing your strengths and keeping your thoughts focused on your successful outcome rather than the arduous journey.

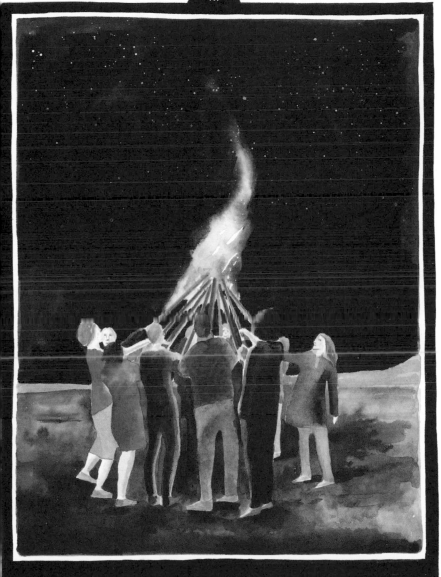

NINE OF WANDS

This last card in the Wands suit symbolizes burden and the hard road. As the finale to the suit of Fire, the **TEN OF WANDS** concludes the inferno that burns so bright in the previous nine cards—and with it comes an element of destruction. This card is a reminder to let go of ego and ask for help. Something may be bearing down on your creative spirit, suppressing your inner fire—this reading is an indication to stay open and let go if need be. Do you have someone whom you turn to when your creative spark is dwindling? Reach out to them today.

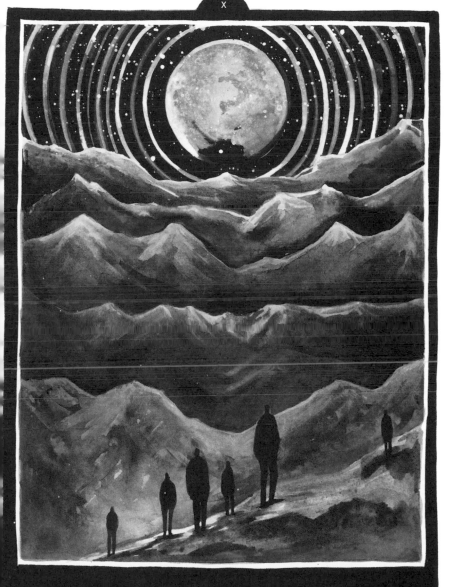

TEN OF WANDS

The **PAGE OF WANDS** symbolizes someone in your life (or a part of your own personality) who is imbued with youthful energy and who sparks your imagination in new ways. This card represents someone full of creative and sexual passion, and someone who aids us in facing our fears and owning them. Again, this could be someone you know or a part of yourself that's been dormant and is now demanding your attention. Channel the Page's energy to manifest your desires right now. It's time to shape your own reality and cast doubts and fears aside.

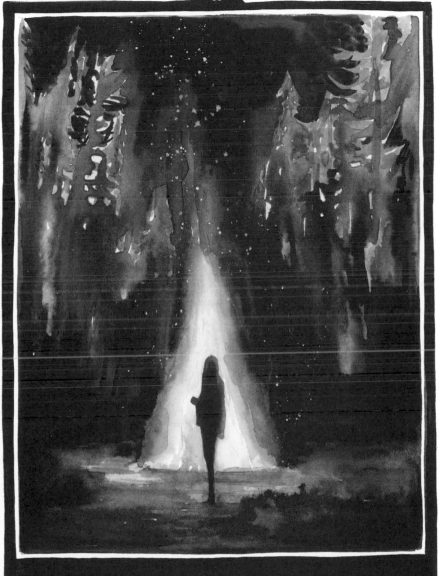

∞

PAGE OF WANDS

The **KNIGHT OF WANDS** is a charming young man poised for adventure who will likely bring unpredictable energy to your life. There is a great deal of passion in this card, and the expeditious manner in which this energy comes (or goes) is key. This Knight is unquestionably fearless and can also symbolize your own fiery energy that's flaming to burst forth. If there is a particular challenge you've been facing for a while, this reading tells you it's time for action and that, if you maintain your focus and channel the energy of the Knight, you will ultimately triumph.

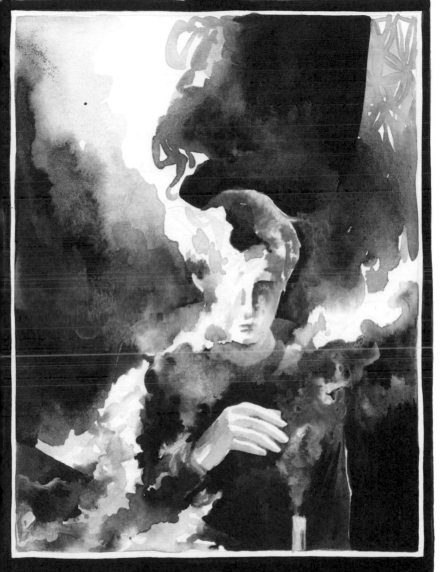

∞

KNIGHT OF WANDS

The **QUEEN OF WANDS** is an exceptionally attractive, vibrant, and honorable woman—and one seething with sexual energy. Fiercely independent and steadfast, she can also be stubborn and unwilling to compromise. She uses the Fire within her suit to ignite imaginations, or to destroy dreams. A very dangerous enemy, she is beauty and wrath personified. The Queen of Wands is asking you to draw on these strengths; do not fear your independence and fortitude, as they will serve you well in the challenges you now face.

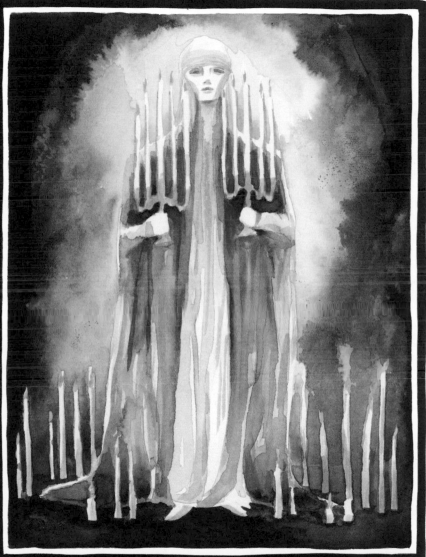

QUEEN OF WANDS

The **KING OF WANDS** is a charismatic and friendly man who is a natural leader—a problem-solver who seems to magically draw others to his cause. He has an innate talent for engaging others and molding them to see the world as he does. His fortitude will see him through any challenge to its inevitable end—for better or worse. Use the King's energy as a reminder to stay focused on your destination and not allow others to sidetrack you from your ultimate goals. You are truly at the helm of your fate, and the more strength and determination you display on this journey, the sooner those around you will follow.

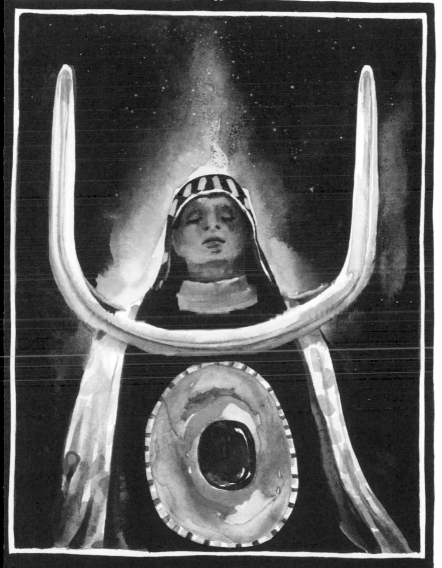

KING OF WANDS

The **ACE OF CUPS** is one of the more spiritual cards within Tarot. The waters within the cup are overflowing, and likely so are your emotions right now. Like most Aces, this is a card of new beginnings—particularly, new love. While it does not necessarily predict that new love is on the horizon, it speaks of its great potential; above all, the Ace of Cups is asking you to open your heart and be ready for anything. It's symbolic of the waters of life— use them to replenish and start out anew.

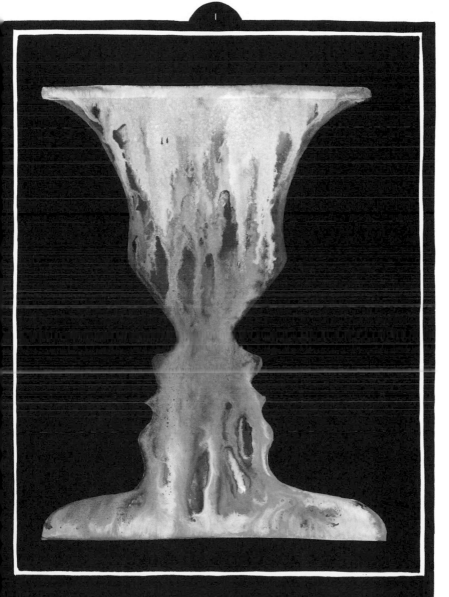

ACE OF CUPS

Much like the Lovers card in the Major Arcana, the **TWO OF CUPS** speaks to a union of souls. While the reading is symbolic of a new connection or attraction to another person (romantic or platonic), it does not necessarily forecast lasting love, but instead it signals a newfound fascination with another. Burgeoning relationships can be difficult to navigate, and the Two of Cups, while asking us to be open to the possibilities of great love, reminds us that it also takes perseverance and patience to truly experience the wonders of a healthy relationship.

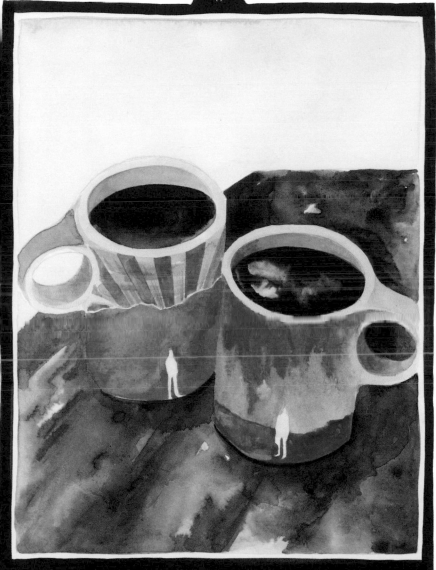

TWO OF CUPS

The **THREE OF CUPS** heralds great joy. This is a card of community; it can foretell of support and love from your truest friends—or speak of greater celebrations that bring people together. It is a reading that is full of happiness. Say yes to all invitations right now and look to the Three of Cups as inspiration to go out with friends. Your loved ones will support you in all your endeavors right now, and you will shine socially, so embrace the moment.

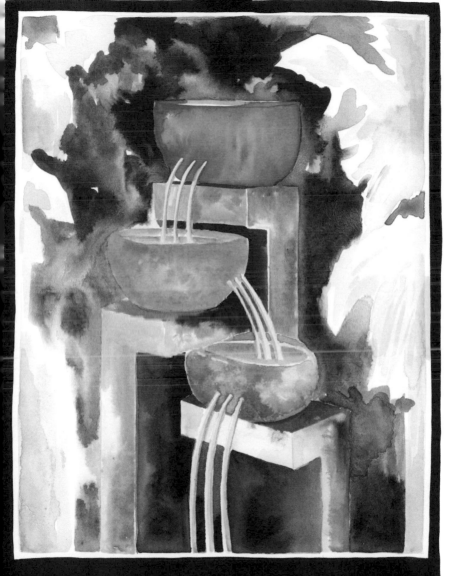

III

THREE OF CUPS

The **FOUR OF CUPS** stands as a card of warning. You have realized many of your aspirations and have likely found great love and friendship that have become part of the foundation of your success. But often when things are so easy, we begin to take for granted not only the sacrifices others have made on our behalf, but the riches we've gained in the process as well. While the Four of Cups affirms your success and happy relationships, it also stands as a firm warning to not become complacent, selfish, and greedy. Take a moment today to say "Thank you." You know exactly who needs to hear it most.

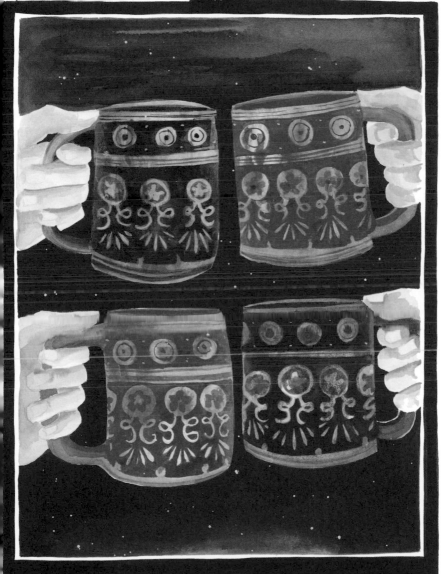

FOUR OF CUPS

In the progression of the Cups suit, the overarching message of the **FIVE OF CUPS** naturally follows the Four. If you ultimately choose to allow greed and self-ishness to take over, grief and regret will surely follow in their wake. You are likely suffering a loss or heart-ache, and instead of confronting it as an opportunity for growth and renewal, you are allowing the shadows to consume you. The past may be haunting you right now, but the Five of Wands also reminds you there is time to set things right. The proverbial light is peeking through the darkness, beckoning you forward. It is ultimately up to you to decide to stay in the shadows or to step into the embracing warmth of the sun again.

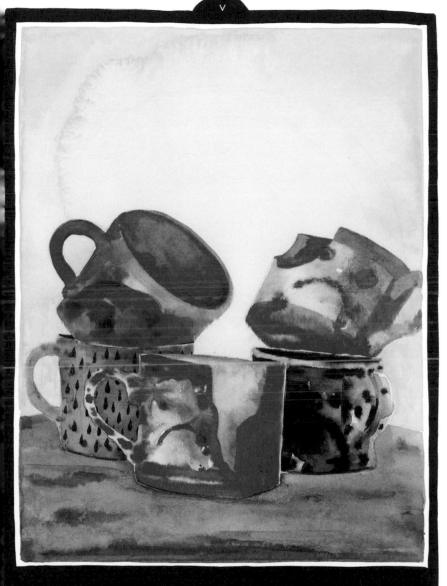

FIVE OF CUPS

The **SIX OF CUPS** gently prods you to turn around for a moment and look at the path behind you. We are told not to dwell in the past, and that true happiness comes from being present and in the moment. The universe, however, is asking you to reflect on your fondest memories, to find joy and take inspiration from those times. The danger lies in casting your gaze back with regrets. Don't look back with longing; reflect on these thoughts with the future in mind, knowing that each step you've already taken on your path has led you to better self-understanding.

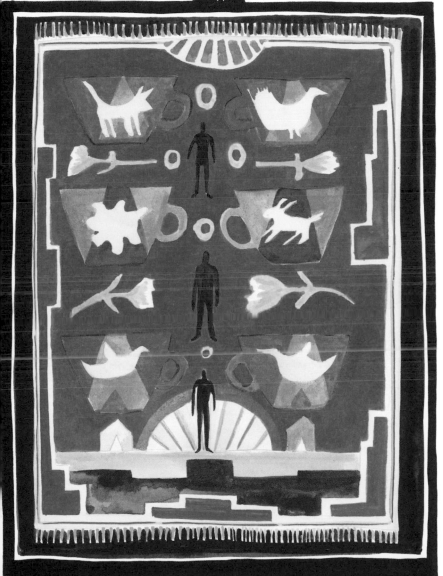

SIX OF CUPS

Many of us are daydreamers. It can be all too easy to slip quietly inside yourself and create a world in which your deepest desires are blissfully realized. The **SEVEN OF CUPS** warns, however, that you've allowed your imagination to run away with you, resulting in illusions that cannot possibly be fulfilled. A vivid imagination can be a sacred gift, but allow it to consume your reality and you will surely feel the desperate heartbreak that only we can inflict upon ourselves. The Seven of Cups can also represent a deception—either from an outside source or your own disillusionment. Open your eyes today and be especially mindful of your current reality. It's okay to walk upon the clouds on occasion; simply keep your gaze firmly fixed on the earth.

SEVEN OF CUPS

The Cups suit is linked to our emotional well-being, and the **EIGHT OF CUPS** stands as a warning that your energy has become stagnant. Either a situation or a relationship in your life has left you depleted creatively, emotionally, or physically, and you may feel it would be easier to completely abandon the situation. This reading is asking you to simply stop for a moment, look at this time to evaluate yourself, and tap your deepest reserves of strength once again. Disappointment is inevitable at some point in our journey; what makes the voyage epic is our ability to continue to move forward. Today, open yourself up to something new and look for a deeper spiritual meaning in the process; here you will find your path is illuminated once again.

EIGHT OF CUPS

Life is opening her arms to you now and asking that you embrace her fully. The **NINE OF CUPS** is also widely referred to as the Wish Card because it foretells bliss (physical and emotional rather than spiritual) and wishes granted. It can speak to the happiness of a solid, soulful friendship or the butterflies that beat their wings in your belly amid new romantic passions. Everything in your life seems to be in harmony, and you should take the time to enjoy this moment. Fasten yourself onto the rush of excitement that accompanies this card, indulge in it, and seek out its gifts daily.

NINE OF CUPS

The Cups suit completes its progression with a card that is bliss realized. The **TEN OF CUPS** radiates joy and signals that for the time being no worries can penetrate your happiness. Peace and harmony will reign supreme in your home and family life right now. Everything will feel balanced, nurtured, and full of hope. Spend time with your family or loved ones today, creating new memories you can reflect upon when the sun of this card has set. If there is unrest, this is the ideal time to come together and resolve your differences. The Ten of Cups asks for nothing more than your happiness.

TEN OF CUPS

The **PAGE OF CUPS** is a romantic, creative, and often restless soul. He is a dreamer who frequently has a difficult time dealing with some of the harsher realities of everyday life. His youthful exuberance serves him well when his ever-active imagination is sparked, however. He is a reminder that it's perfectly acceptable to allow your heart to lead you upon occasion, especially in your creative endeavors. Our emotional map is a sacred landscape, and he reminds us that in order to be whole, we cannot acknowledge the steadfast reasoning of our head without considering the tumultuous ocean of our heart. If that battle has been raging inside of you, it's time to follow your heartbeat.

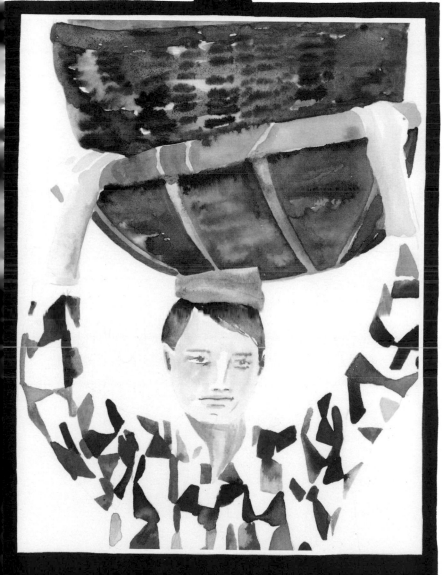

PAGE OF CUPS

The **KNIGHT OF CUPS** is peaceful and introspective. This reading asks you to stay open and balanced. If there is a quiet passion you've been harboring—perhaps a new hobby—the Knight of Cups is relaying that it's time to pursue your desires with determination and focus. It's painfully easy to be consumed with your day-to-day routine, and it's now time to step outside of your carefully crafted box. A storm of intensity lies within you, and your dreams are ready to be made manifest; just be mindful of the balance he asks of you. The Knight of Cups is intensely passionate about following his dreams, so take his lead and follow yours.

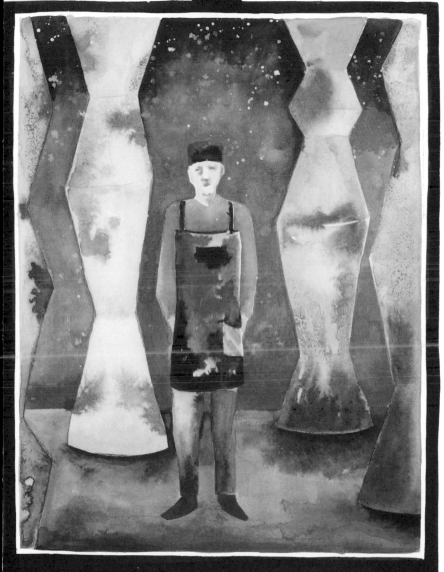

KNIGHT OF CUPS

The **QUEEN OF CUPS** is the most powerful psychic and insightful Queen apart from the High Priestess. Like the others that dwell within her court, she is full of beauty and dreams, and she often leads with her heart instead of her head. A natural mother and creative spirit, the Queen of Cups symbolizes your emotional security, but be mindful of her tendency to delve too deeply into herself. She speaks to you now with the soft whisper of a loving mother, asking you to follow your heart and share your knowledge generously with others. Through this course you will learn to balance your visions and your reality.

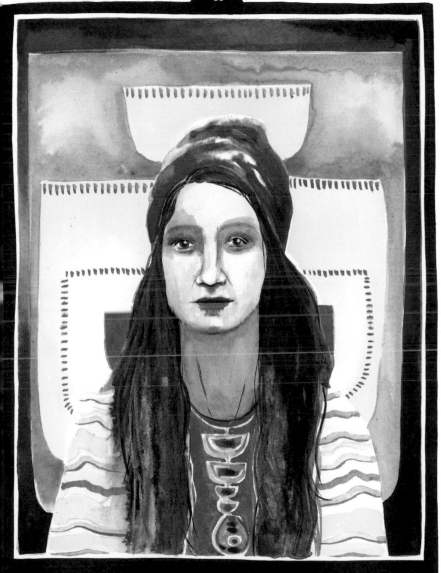

QUEEN OF CUPS

The **KING OF CUPS** is the most romantic of the Kings and an artist at heart. He is supportive, diplomatic, and brimming with confidence. He appears as a call to handle present situations with grace and dignity rather than force. It can be difficult to rise above emotional currents that attempt to sweep you into turbulent waters, but with this King on your side, your discretion will be your lifeline. Above all, this reading asks for emotional balance. Take a moment today to consider a problem at hand. What can be gained from letting your head take the lead and smoothing your emotions over with a balm of reason? Likely, a great deal.

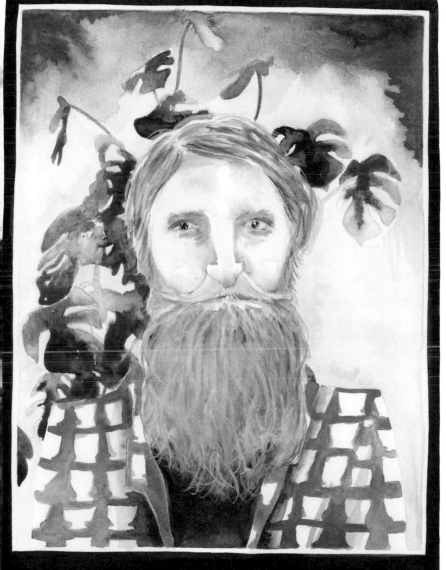

KING OF CUPS

The **ACE OF SWORDS**, like Aces throughout the entire deck, speaks to new beginnings. The Swords cards possess a duality that none of the other suits quite match, however. Like any blade, the Sword has two sides. While the Ace of Swords is a card of truth and grants the ability to see a situation in a new light, it can also speak of a great power that must be handled with care. If you've been struggling with a situation, this reading grants mental clarity, allowing you to see things anew and to move forward.

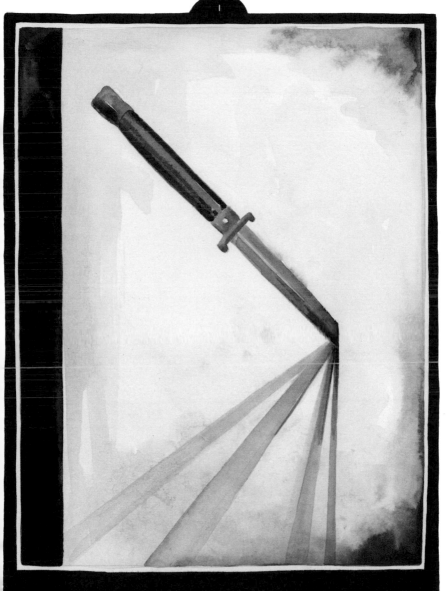

ACE OF SWORDS

The **TWO OF SWORDS** foretells a stalemate. There are always two sides to a situation, and you must fight through your blocked vision to balance each. This duality may manifest at work or perhaps in a relationship, but know that you need to be both open and willing to compromise in order to move forward. Furthermore, the truth of the issue may be purposefully hidden from you, or you may be choosing to ignore it—either situation should be rectified. Unbind your eyes and open your heart to possibilities right now.

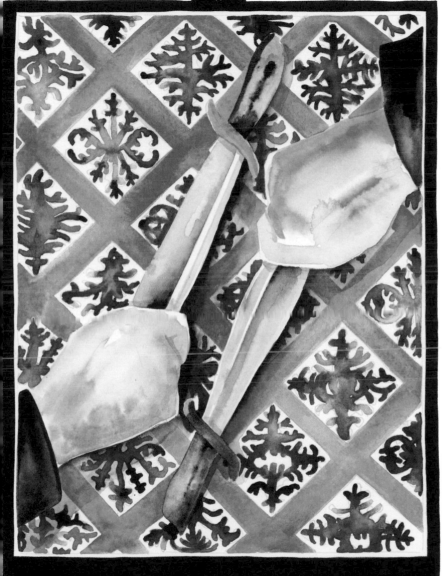

TWO OF SWORDS

The **THREE OF SWORDS** represents betrayal and heart-break; this reading always pertains to emotional pain. As you've experienced throughout your life, the tides of contentment and sadness ebb and flow. What enlightens our spirit and sense of self is what we take from all of these experiences and how we allow those moments to shape us. Steel yourself for unpleasant news, but realize that this will lead to a powerful lesson from the universe, one from which you will surely gain valuable insight. The Three of Swords stands as a reminder that you are strong enough to weather any tempest.

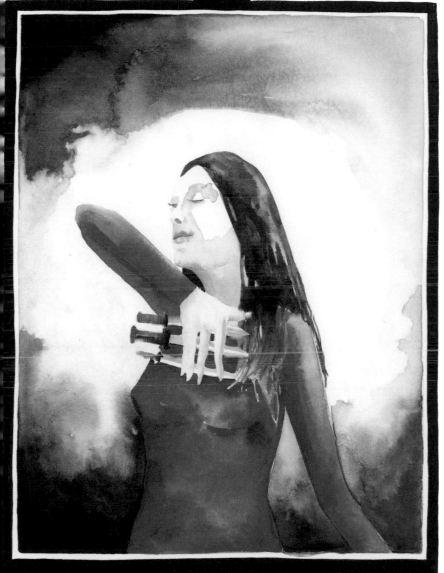

THREE OF SWORDS

The Swords suit is full of upheaval and turmoil, and the **FOUR OF SWORDS** asks that you rest your heart and soul and prepare for the challenges that await. When we find ourselves in the midst of chaos, it can be difficult to stand still. We believe doing something—anything, really—can be better than what we are currently experiencing. But the Four of Swords asks you to embrace stillness and tap into your mental power. Look to this reading as a sign that you've reached a halfway point through your trials . . . you're almost there, so take the time today to rest your mind.

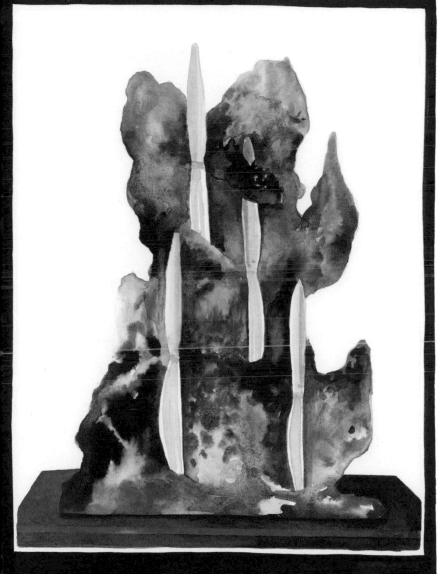

FOUR OF SWORDS

The **FIVE OF SWORDS** can represent the negative influences of ill-placed ambitions. You may have recently been served an especially bitter defeat, made more so because you've convinced yourself that you should have been victorious. This can lead to your self-destruction if you keep a closed mind about the situation. But remember that there are two sides to every blade. The Five of Swords is a reminder to stay open to the changes that defeat has brought. What can you take from this loss so that you can taste victory once again?

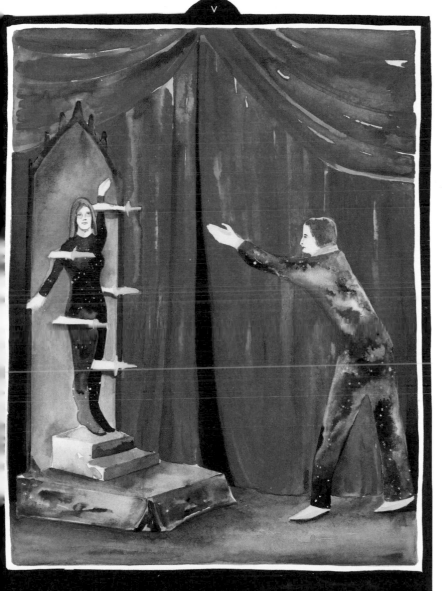

FIVE OF SWORDS

We are often told that if we work diligently enough and are passionate, we can manifest any reality we wish. This is not always the case, however—sometimes your best course of action is to simply move on and start anew. The **SIX OF SWORDS** speaks to travel and physically moving away from certain challenges. Do not look to this reading as a message to run away, but rather to start fresh and be hopeful about the future. Take a moment to emotionally step back from the turmoil you've recently been experiencing to ask yourself what could be gained by a truly new perspective.

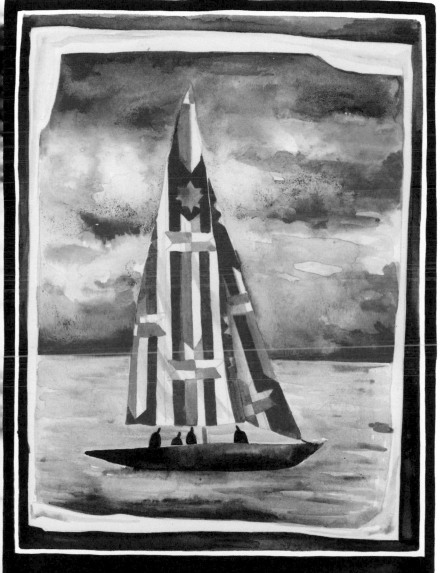

SIX OF SWORDS

Like so many of the cards within the Swords suit, the **SEVEN OF SWORDS** stands as a warning. Your self-interest and secrecy will surely be your undoing. You may be keeping secrets (or others are keeping them from you), and they will prove to be detrimental to all involved. You may realize victory through this deception, but it will be short-lived. If you allow this behavior to continue, you risk being haunted not only by the outcome, but also by those you've hurt and betrayed in the process. It's time to step out from the shadows and be accountable for your actions.

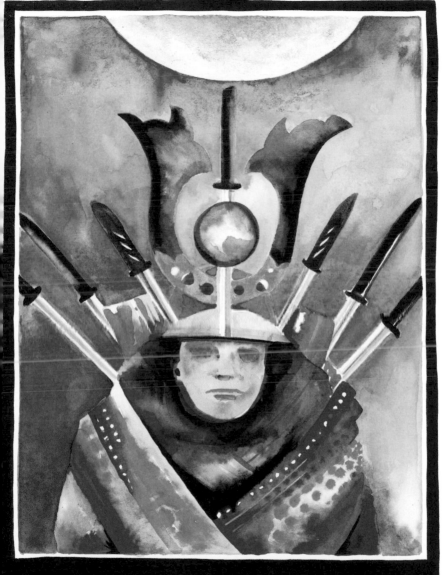

SEVEN OF SWORDS

The **EIGHT OF SWORDS** forewarns that you may be trapped and powerless against a situation. You're emotionally bound to something or someone, and it's blocking you from seeing the truth at the heart of the matter. The most challenging aspect of moving forward is that only you have the power to remove your own blindfold. You may feel helpless, but this card shows you that you must take a stand, shed what binds you, and move forward.

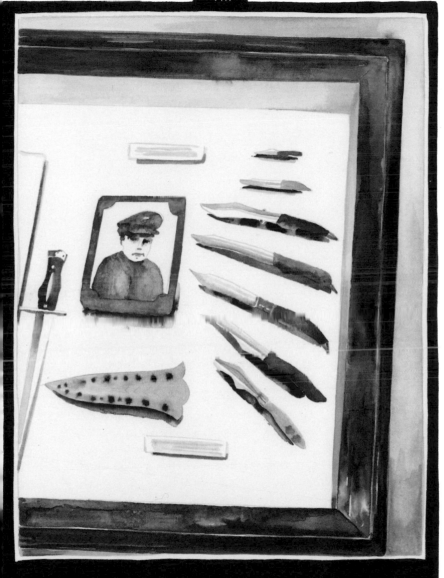

EIGHT OF SWORDS

The **NINE OF SWORDS** often accompanies nightmares and exposes your inner anguish. It may be a reminder of deep emotional wounds that have not yet healed, but more commonly, it speaks to anxieties that are self-inflicted. The emotional weight of your fear is what haunts you now, and the Nine of Swords is forewarning that holding on to such trepidations can manifest in your reality. Take a deep breath; know that you are stronger than you imagine yourself to be. Be warned that by allowing your disquiet to cripple you from moving forward, you will drown in uncertainty.

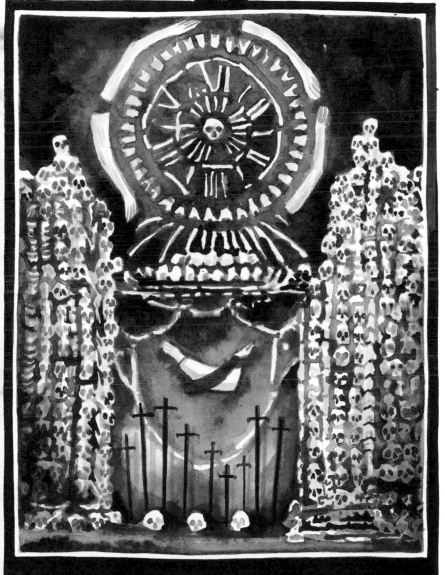

NINE OF SWORDS

The **TEN OF SWORDS** foretells an unexpected misfortune, one that will shake your very foundation. In certain circumstances, you may be able to forestall or even change the outcome of this situation, but more often than not, you will have to face an inevitable collapse—you are at rock bottom and have been utterly defeated. While this fortune may be unwelcome, as all Swords do, this card asks you to look within yourself to rise again. Lessons learned from defeat and sudden turmoil are often the ones that stay with us the longest and teach us the most about ourselves.

X

TEN OF SWORDS

The most insightful of all the Pages, the **PAGE OF SWORDS** succeeds at balancing matters of the heart and head. She can be especially observant and have the ability to see things in a way others cannot. She is especially skilled at utilizing that gained information to her advantage while still maintaining diplomacy. However, like all Pages, she is in the nascency of her youth and can be overtly direct if provoked. Channel the Page of Swords to seek new perspective; whether it be a situation at hand or the desire to try something new, the Page will guide you decorously.

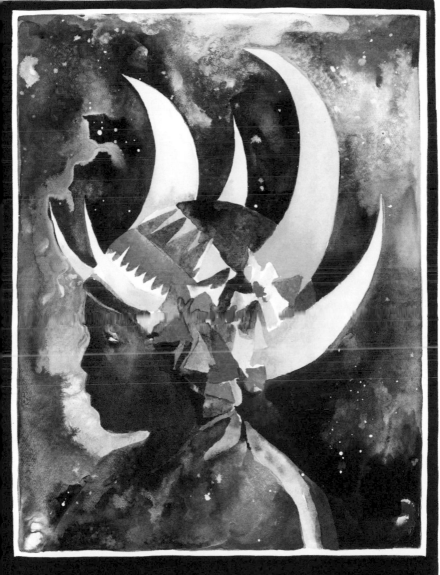

PAGE OF SWORDS

The **KNIGHT OF SWORDS** seems to stand in direct opposition to the Page. When diplomacy fails, the Knight believes in a fearless, determined, and often forceful approach. He chooses to use action over words to resolve conflict, and he suppresses emotions so much that he's often believed to be heartless. While it may seem unfathomable to channel his violent sensibilities, there are times in life when a direct, emotionless approach will gain you more ground in your confrontation than tact and patience. The Knight appears now to remind you that using such a methodology has its place and now may be the time to embrace your inner warrior.

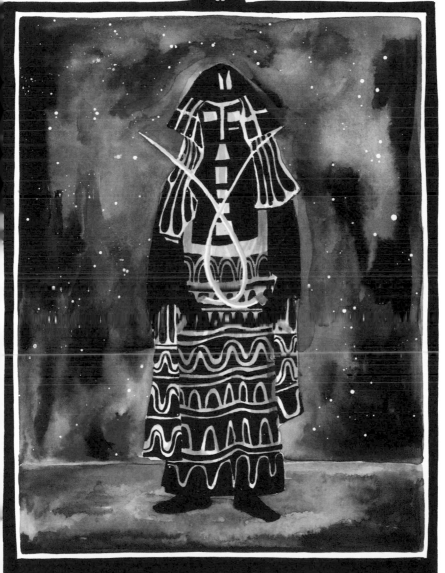

∞

KNIGHT OF SWORDS

The **QUEEN OF SWORDS** represents someone with great life experience, and who is all-seeing. She is steel, can cut quickly to the truth, and has little tolerance for dishonesty. This Queen can be cold, calculating, and overbearing in her nature, and she may not allow others to voice opinions; she expects those in her life to deliver fully on their promises. Channel her unabashed power to free yourself from the weight of emotional bindings. She's encouraging you to seek the solution to a problem with brutal honesty and suppressed compassion. While this may not always be the way to view the world, the Queen knows that there are some matters that can benefit greatly from her icy insight.

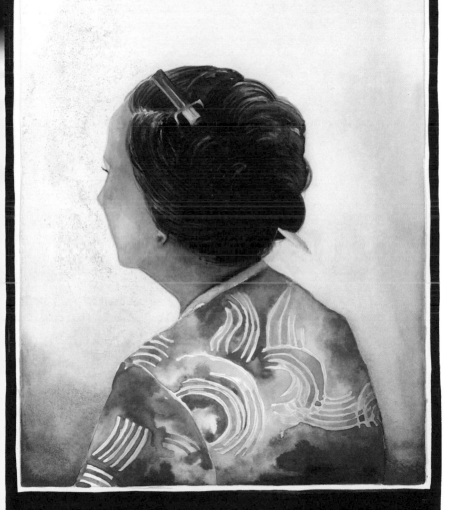

QUEEN OF SWORDS

The **KING OF SWORDS** is seen as a fair and just judge of both character and matters at hand. Though deeply devoted to friends and family, much like his Knight he can seemingly lack emotion and empathy for others. This King is an analytical decision-maker, and like the others in his court, he leads with his head as opposed to his heart. He appears when you need to swallow the sentiments that may be suffocating you and preventing you from making a sound and just decision. Channel his calculating insights to see yourself through emotionally draining waters.

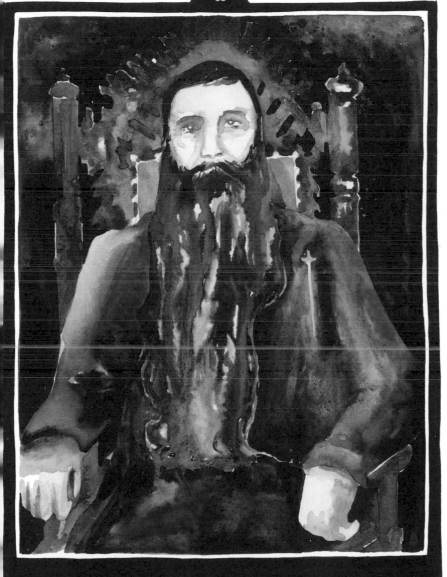

∞

KING OF SWORDS

Like all Aces, this is a card of new beginnings. The **ACE OF PENTACLES** foretells prosperous beginnings in work. The universe is telling you it's time to plant the seeds that will inevitably bear the fruit of wealth and success. This reading stands as a reminder that all you desire is within your reach if you tend to your goals carefully. The Ace of Pentacles can also foretell unexpected gifts. Is there a project you've been considering for some time but have had problems getting off the ground? Now is the time to revisit that venture.

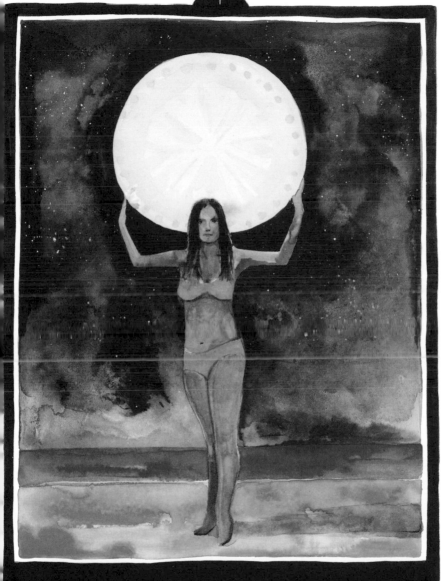

ACE OF PENTACLES

The **TWO OF PENTACLES** signals a change pertaining to work, home, or income. Change is inevitable, but keeping ourselves grounded allows us to embrace change rather than fear it. You must find a way to balance the stemming tide so as not to tip the scales; emotional stability will see you through this time clearly. The Two of Pentacles asks that you keep your head clear and heart open, remain flexible, and know that wherever the current carries you, it's part of your inevitable journey to happiness.

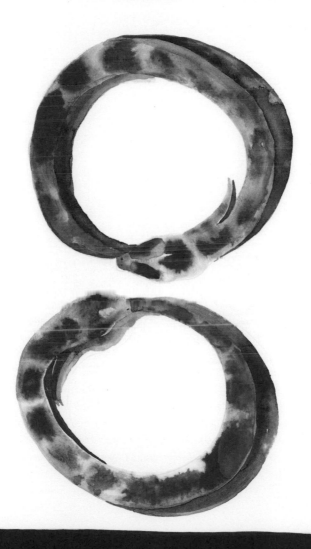

TWO OF PENTACLES

Sometimes everything seems to be stress-free and pain-less. But more often than not, we have to work diligently and focus our energy completely toward the task at hand. The **THREE OF PENTACLES** is a card of encourage-ment. It reminds you that you're now at the foot of the summit, and as long as you continue to work hard and remain focused, your determination and will to succeed will pay off. This card is also a reminder that you likely didn't make this journey alone; as a card of collaboration, it reminds you to take the day to thank those around you who both encouraged and aided your journey.

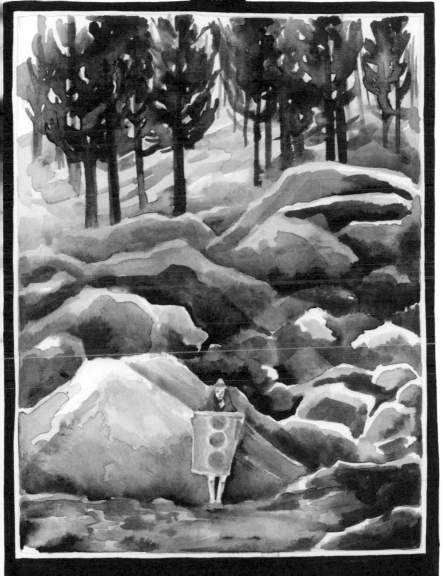

THREE OF PENTACLES

The **FOUR OF PENTACLES** speaks of a battling duality and stands as a warning. You likely have benefited greatly from your perseverance and hard work; you very well may be experiencing the rewards of due diligence. While riches may be at hand, however, do not allow possessiveness to dictate the choices you make. The Four of Pentacles asks you to let go of greed and the overt temptation to value your success above all else. The greatest message in this reading is release. Today, let go of any toxic emotions binding you, and you will again be free.

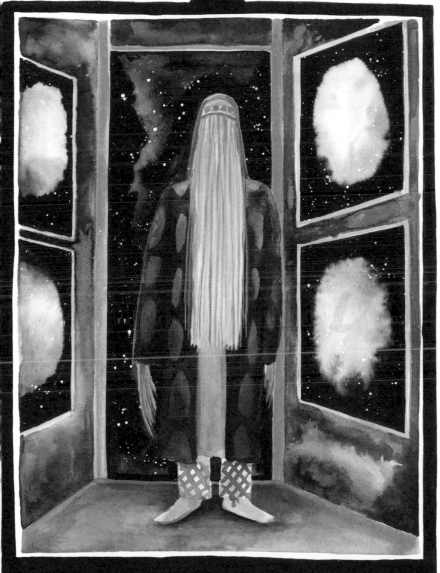

IV

FOUR OF PENTACLES

The **FIVE OF PENTACLES** is a card of loss, sadness, and possible illness. It warns that by holding on too tightly to possessions, we forfeit ourselves spiritually, and in turn, that loss can become material. While it can be difficult to gain insight on what the future now holds, the Five of Pentacles is also a call to stay open to the change that this loss will bring. Use this opportunity to learn and grow from this inevitable transformation; you will be sounder and more enlightened from the experience.

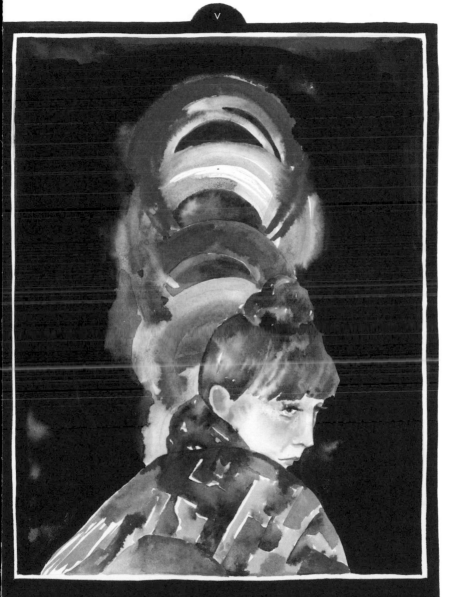

V

FIVE OF PENTACLES

The **SIX OF PENTACLES** is a quintessential example of the chronological progression of Tarot. After so much darkness in the Four and Five of Pentacles, you will finally experience prosperity and spiritual growth. There is harmony and balance in your financial life right now, and the Six of Pentacles also calls for your generosity. Open your heart and pocketbook to others; spend time mentoring someone and sharing your wisdom. There is someone in your life who needs you more than ever; seek them out today and inquire how you can help. Your heart will be alight from the effort.

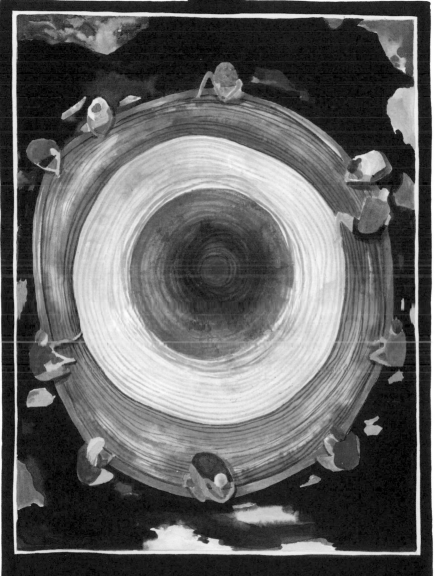

SIX OF PENTACLES

The **SEVEN OF PENTACLES** is a card of contemplation. It suggests that you've attained your reward, and you may now find yourself pondering your success. It is completely natural to wonder whether you truly gave all you could. But take heart, rest and reflect. Do not allow the underlying frustration you may be feeling about your effort to cloud the sun. Though you may be driven to immediately climb the next mountain, the valley may suit you beautifully. Enjoy this moment, and take today to truly acknowledge your success—own it and celebrate.

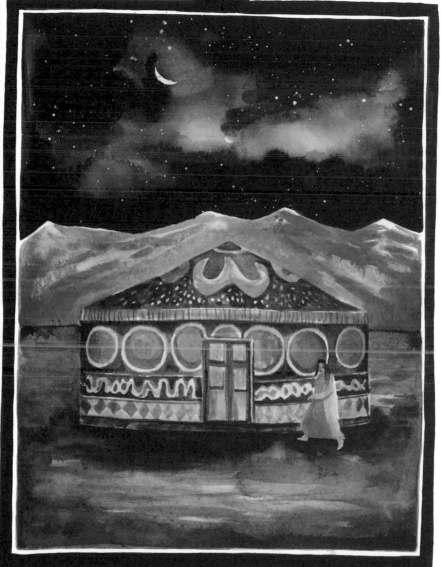

SEVEN OF PENTACLES

The **EIGHT OF PENTACLES** is speaking directly to your craftsmanship and skill. This is the time to be steadfast in your attention to detail and to hone your gifts. It can be tempting to daydream about where your labors will finally lead and forsake the lessons learned on the road itself. Do not look to the end, but embrace the journey and relish the practical knowledge that you'll gain from the experience. Your steadfast commitment will bring great reward, and the spiritual wisdom gained from your efforts will be invaluable.

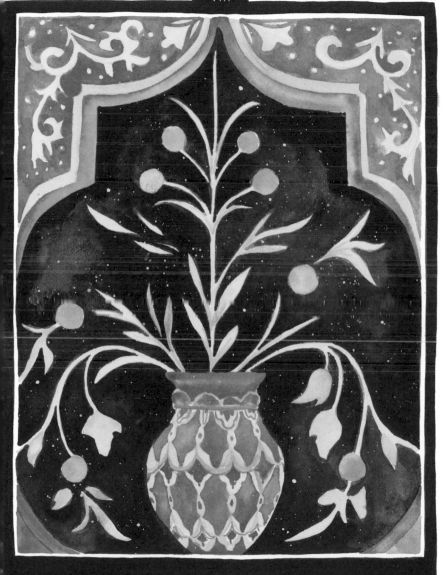

VIII

EIGHT OF PENTACLES

The **NINE OF PENTACLES** is one of the happiest readings in the deck in regard to your family and home life. You've worked hard to attain your happy home and material wealth. In a sense, some of your greatest wishes have come true. Take the time to enjoy your rewards, and do not pine for more at this time; be present in the moment and grateful for your blessings. The Nine of Pentacles can also speak to a spiritually healthy home. Today, take the time to acknowledge the importance of balancing your spiritual and material wealth.

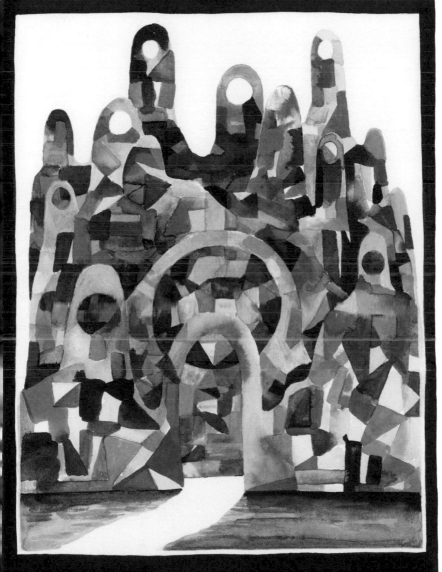

NINE OF PENTACLES

The Pentacles suit closes with a card that reflects your achievements. You've attained wealth—both material and spiritual—and this card appears to suggest it's now time to pass on your gifts to your friends and family. The **TEN OF PENTACLES** asks you to be generous with both your finances and your time in helping others succeed. It also encourages you to seek balance, as holding on to your wealth too tightly or trying desperately to accrue more can both lead to detrimental effects. This is the time to allow yourself to feel fulfilled and truly happy.

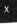
X

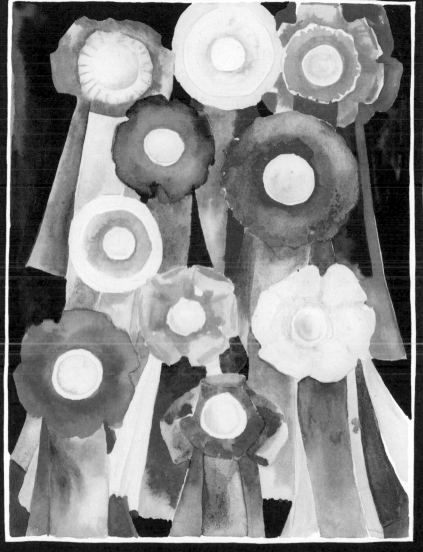

TEN OF PENTACLES

The **PAGE OF PENTACLES** is the most responsible and grounded Page in Tarot because of her relationship to earth. She is a steadfast worker who is instrumental to your success—though she may work exclusively behind the scenes. She reflects your unbridled enthusiasm for a new project and gives you the fortitude to get started. An idea for a new venture may have been budding within you for some time; the Page of Pentacles is telling you to act now. You are never more open to new ideas and the attainment of knowledge than when this Page is at your side. What have you always wanted to learn to do? Now is the time to sign up for a class or workshop.

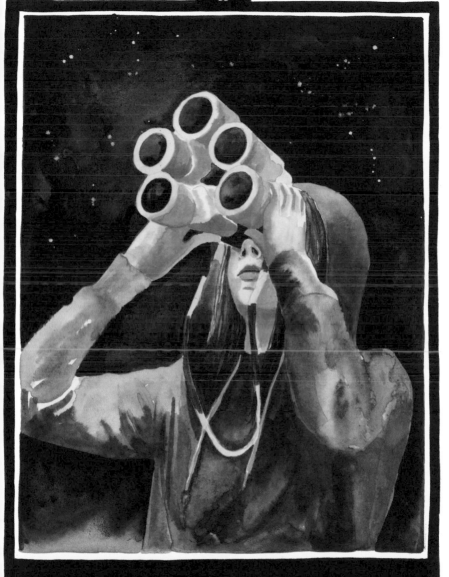

PAGE OF PENTACLES

The **KNIGHT OF PENTACLES** is the most steadfast of the Knights. While he can be closed off emotionally, his determination to see things through and his unwavering loyalty to others know no rival. He is often old-fashioned in his thinking; as such, the Knight of Pentacles stands as a reminder that it's not always in your best interest to dive in headfirst. Let him guide you in taking a step back and contemplating a situation you're facing with reason and logic. Offering encouragement that you are on the right path, the Knight of Pentacles asks you to map out your journey with an open and analytical mind, and you will surely arrive to great pageantry.

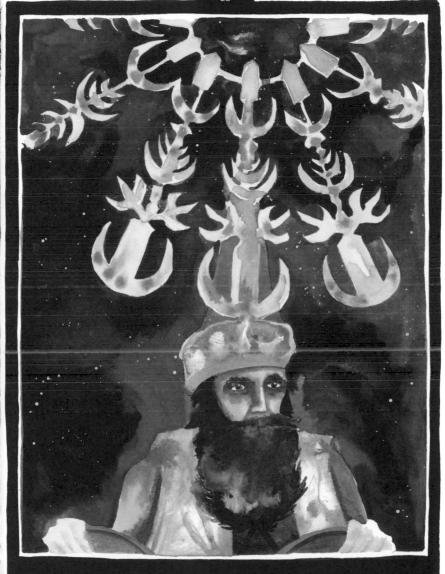

∞

KNIGHT OF PENTACLES

The **QUEEN OF PENTACLES** is highly intuitive. She is a mothering figure—deeply nurturing and domestic. She is dedicated to her family and home above all else. She is also incredibly independent and has worked hard to create a beautiful life for her family. Today, focus on the people in your life who need your love and care. The Queen of Pentacles communicates that we are capable of opening our hearts in ways we may have believed unimaginable. She's encouraging you to manifest your most compassionate self into a spiritual and loving being, all while reminding you that it's imperative to honor yourself and your own needs in the process. Like so many readings in Tarot, she asks for balance, and in the end, you will be whole.

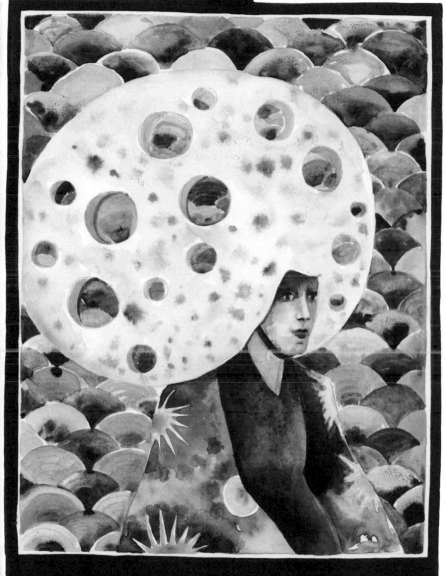

QUEEN OF PENTACLES

Much like the Knight of this suit, the **KING OF PENTACLES** is steady and highly intelligent. His greatest gifts are entrepreneurial, and his ultimate goals are material, though he has a strong sense of spirituality as well. He has an innate gift for paring down any given situation to its foundation, and the ability to focus on utilizing the best possible structure to create success. The King of Pentacles inspires victory, and this reading is a message that you indeed are on the right path for both economical and spiritual growth. Embrace reason and take control, and you will inspire others to do the same.

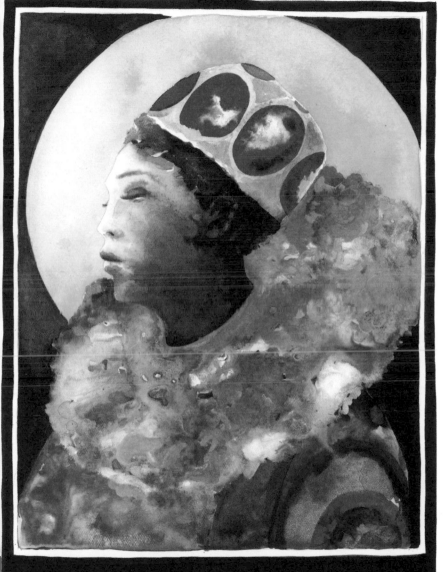

∞

KING OF PENTACLES

Library of Congress Cataloging-in-Publication Data available.

ISBN: 978-1-4521-4195-4
Manufactured in China

Design by Brooke Johnson
Typeset in Brandon Text and Brandon Grotesque

10 9 8 7 6 5 4 3

Chronicle Books LLC
680 Second Street
San Francisco, CA 94107

www.chroniclebooks.com